D1453656

THE STEINWAY COLLECTION

THE
STEINWAY COLLECTION

Paintings of Great Composers

WITH ESSAYS BY JAMES HUNEKER

Classical Music Today • Amadeus Press

Published in 2005 by Classical Music Today, LLC

Published by arrangement with Amadeus Press, LLC
512 Newark Pompton Turnpike, Pompton Plains, New Jersey 07444, USA
Website: www.amadeuspress.com

Printed in Canada

ISBN 1-57467-115-4

Library of Congress Cataloging-in-Publication Data is available upon request.

CONTENTS

FOREWORD

THE *period from about 1880 until 1920 was a golden age in American art and musical performance. Growing American cities were blessed with constant visits by the best European singers, pianists, violinists, and theater companies. Orchestras were being formed everywhere. America was the place for foreign-born artists to make their fortune, and many of them made it their home. Everyone who was anyone was here. At Carnegie Hall on January 16, 1910, for example, Sergei Rachmaninoff could be heard performing his Third Piano Concerto, newly composed for America, with the New York Philharmonic conducted by Gustav Mahler. Imagine!*

Newspapers and magazines were abundant, and reporting on the arts prolific. One could easily read eight or ten articles on any event, although many of the reviews were arid and pedantic. There were bright spots, however, especially in New York City, with its theater, Carnegie Hall, the Metropolitan Museum of Art, and the Metropolitan Opera featuring the great Caruso and Toscanini. The daily papers stocked teams of solid professional critics such as Krehbiel, Finck, Henderson, Gilman, and Aldrich, each giving readable chronicles of an exciting era.

Within this strenuous reportage and tabulating of music, performance, theater, painting, and literature arose a critic of genius, a writer of the seven arts. For me, his name is hallowed: James Huneker, born in Philadelphia in 1857. He was, as H. L. Mencken said, "the one critic among us whose vision sweeps the whole field of beauty. . . . It is unquenchable, contagious, inflammatory."

Huneker broke through the entrenched Puritan framework of the age, literally shocking the cultural scene with a fountain of rhapsodic prose deftly combined with a profound instinct for critical verisimilitude. By the pure joy he received from the arts he opened the sensibilities of the young and susceptible. His presence in New York made a celebrity of a critic.

The man was as fascinating as the writer. Listening to his talk, Mencken recalled, "The most amazing monologue that these ears had ever funneled into this consciousness. What a stew, indeed! . . . Gossip lifted to the plane of the gods. . . . I left in a sort of a

fever." Huneker's books breathe his fervent, surging energy.

"Jim the Penman," as he called himself, at times hectored his audience but, mostly, through heated enthusiasm brought to their lives the dazzling array of work that had been and was being created in Europe and Russia before the First World War. He told them of Tolstoy, Dostoyevsky, Ibsen, Matisse, Schoenberg, Debussy, Maeterlinck, Havelock Ellis, Cézanne, Nietzsche, Rodin, Monet, Zola, George Moore, Huysmans, and a thousand other now honored names, many decried or misunderstood at the time.

But Huneker's first passion and last love was the piano, its performers and music. From childhood Huneker worked hard at his piano developing an adequate technique. Later he studied for a year in Paris, auditing classes at the Paris Conservatoire. Huneker also worked with the celebrated Hungarian pianist Rafael Joseffy, who had settled in New York. Huneker called Joseffy "the enchanter who wins me with his disdainful spells . . . his tone as beautiful as starlight." On Joseffy's recommendation he taught for some time at New York's National Conservatory. His Chopin: The Man and His Music, published in 1900, remains Huneker's most read book.

Thousands of young American piano students inadvertently came upon Huneker in the prefaces of the yellow-covered Schirmer editions of the various genres of Chopin's output. As a youngster I avidly read Huneker's "lyric cadenced prose," reading of Chopin and his music with a feeling of intoxication even if I could not understand all that he was saying. I couldn't wait to hear all the music he was describing.

While learning the Chopin Waltz in C-sharp Minor, Op. 64, No. 2, I read these words of Huneker: "The veiled melancholy of the first theme has seldom been excelled by the composer. It is a fascinating lyric sorrow, and the psychologic motivation of the first theme in the curving figure of the second theme does not relax its spell. A space of clearer skies, warmer, more consoling winds are in the D-flat interlude; but the spirit of unrest soon returns. The elegiac note is unmistakable in this veritable soul dance."

Is this not the acme of descriptive analysis? And there are thousands of such examples in Huneker's writings, pertaining to all branches of the arts.

In an article on Huneker in 1987, the pianist Samuel Lipman expressed a similar experience: "As the child stared at the music before him, he found something more in those assorted yellow-bound volumes than mere notes. . . . There were words, too, enchanting descriptions of the Polish composer's music. Indeed, the greatness and romance this child could hardly find emerging from his own exertions he found in the words the kind publisher had provided."

For decades now, Huneker's florid, highly charged prose has been out of fashion. His

twenty or so volumes are no longer devoured by a culturally hungry public. There needs to be a Huneker revival, beginning with Mezzotints in Modern Music *(1899) through* Variations *(1921). Many of the books have suggestive titles, such as* Melomaniacs, Overtones: A Book of Temperaments, Iconoclasts: A Book of Dramatists, The Pathos of Distance, Egoists: A Book of Supermen, Old Fogy: His Musical Opinions and Grotesques, *and* Ivory Apes and Peacocks, *all of them valuable. He wrote two volumes of letters that are full of vitality, and some fiction, most notably a musical novel,* Painted Veils, *that was racy in its day but is now tame, replete with a sumptuous vocabulary.*

In time I had acquired the whole Huneker canon, but in those pre-Internet days his autobiography, Steeplejack, *eluded me. Then one bright day in Lisbon on my way to the zoo I saw a street bookseller. Ah, what a pity not to know Portuguese, I thought. Still, I sauntered over, and there it beckoned—*Steeplejack *in English in mint condition—six hundred packed pages for less than one dollar.*

Huneker's last years were difficult. His health had badly deteriorated, and he was exhausted from nonstop journalism. He died in 1921 at sixty-four. Ever the ironist, he wrote to a friend, "What the hell! I can only die once—and diabetes is such a sweet death!"

In 1919 Steinway & Sons commissioned James Huneker to write texts to accompany the descriptive paintings in The Steinway Collection, *which remain today on display at Steinway Hall in New York. The collection was previously released only as an in-house publication of Steinway & Sons. Amadeus Press felt that after nearly ninety years, the wide piano-loving public would be delighted to see and read this extraordinary compilation.*

Of these paintings, James Huneker wrote, they "evoke musical visions; for music is visionary, notwithstanding its primal appeal to the ear."

David Dubal
New York City
Autumn 2005

PRELUDE

 prelude that praises pictures should be expressed in terms of tone; but as the present collection is a paean in honor of great composers and their music, other than sober prose would be inutile. It was an admirable idea of Steinway & Sons to enlist the sympathetic co-operation of certain American artists in the creation of pictures that would evoke musical visions; for music is visionary, notwithstanding its primal appeal to the ear. Walter Pater was perfectly justified when he described music as an art to which other arts aspire. Nevertheless, to invest tonal arabesques with form and color has always proved a hazardous experiment, because it presupposes a knowledge of the theme on the part of the spectator, and a felicitous interpretation on the part of the artist. Yet an experiment worthy of trial; above all, an interesting one. It was Franz Liszt who declared that his ambition was to play in the Salon Carré of the Louvre, that treasure gallery, where to the challenging glances of Da Vinci, Giorgione, Rembrandt, Titian, Paolo Veronese, Raphael and other miraculous creations, he would discourse his own magical music. We have no Liszt now to play his homage to the Steinway pictures, but if he were to revisit these glimpses of the moon, he would find himself at ease in this assemblage. How he would reveal the colossal music-dramas of Wagner, the symphonic scenes of Beethoven, the tender and poetic songs of Schubert. Conjure up the thrill he would arouse by his dramatic performance of the Erl-king. Rubinstein, Mendelssohn, and the thrice-subtle Chopin he would interpret; stately Handel and romantic MacDowell; Berlioz and Mozart, storm-cloud and sunshine, he would make live again, and Verdi, too, master of operatic climaxes. That no one played Liszt like Liszt is musical history. We long to put back the hands of the clock of Time.

But let us not tarry too long in this region of pleasing surmise. The pictures herein must play themselves in the imagination of the onlooker. They are largely illustrational as befits their subjects. Normal canons of art that proscribe the mingling of two dissimilar arts should be forgotten and the mind left unhampered to enjoy the fantasy of the conception. No one but a poet could dare bend the bow of such a Ulysses as Berlioz. Or the overarching utterances of Beethoven, can they even be hinted at? All

styles may be noted, no painter was asked to conform to any set scheme. Homely pathos, tragic abandon, nature in her sweetest April garb, the roar of the Erl-king's icy blast, the sheer gossamer loveliness of the Midsummer Night's Dream, the fierce onset of battling Indians, Handel and his flowing Fire Fugue, the death of Mozart, the fevered vision of Chopin, Rubinstein and his royal auditors, Liszt and Wagner, and again Liszt, the aged magician weaving his spells in the loneliness of his latter years, Verdi and his tropical music—here are composers from many lands, who have held the world in thrall for a century and more. No need to emphasize their eminence. Music lovers in America will welcome the evocations of these musicians set forth by the brush of native painters and illustrators of renown. And Steinway & Sons are quite qualified in presenting these pictures. Are they not artists themselves in the production of an instrument that rivals in tonal charm an exquisite Stradivarius!

THE
STEINWAY
COLLECTION

The Raindrop Prelude. Painted by A. I. Keller

CHOPIN

EORGE SAND, the novelist, played the rôle of maternal secretary to the Polish composer, Frédéric François Chopin. She it was, even before Liszt, who interpreted his personality and music in her supple prose. The history of her life tells us of her sojourn on the Isle of Majorca with the sick, nervous composer. It was at the deserted monastery of Valdemosa, which for him was full of terrors and phantoms, but only interesting to her more robust imagination. Often on returning from her nocturnal rambles with her children she would find him at the keyboard, pale, his eyes haggard, hair on end, unable to recognize them at once; and then, after an attempted smile, he would play sublime things, terrible, heart-rending ideas that had obsessed him in his hours of sadness and solitude. Some are the visions of deceased monks and the sounds of funeral chants, which beset his fancy; others are sweet and melancholy—they came to him in the hours of sunshine and health, with the noise of the children's laughter under the window, the distant sound of guitars, the warbling of the birds among the humid foliage, and the sight of the pale, little roses on the snow. Others, again, are of a mournful character, and, while charming the ear, lacerate the heart. Thus George Sand, concerning those compositions modestly entitled by the composer, *Preludes*. Of them Robert Schumann wrote: "I must signalize them as most remarkable. I will confess I expected something quite different, carried out in the grand style of his studies. It is almost the contrary here; these are sketches, the beginnings of studies, on, if you will, ruins, the feathers of eagles, all strangely intermingled. But in every piece we find in his own hand, 'Frédéric Chopin wrote it.'"

The *Preludes* were published in 1839, the same year of the trip to the Balearic Island; nevertheless, there is internal evidence to prove

that most of them had been composed before. This fact upsets the legend about the music-making at Valdemosa. George Sand relates that once, with her son Maurice, she had gone to Palma, where she was overtaken by a storm. Chopin's anxiety increased as they failed to return. Despairingly he improvised the famous *Prelude in D flat*, his face bathed in tears. After much danger and delay the mother and son entered late at night his monastic cell. He called out as if startled from the dream of a somnambulist: "Ah! I knew well that you were dead!" He later told her that he had seen, as if in a vision, all the hardships she had experienced. Like the young artist in the *Fantastic Symphony* of Berlioz, Chopin dreamed that he was dead. He saw himself drowned in a lake; heavy, ice-cold drops of water fell at regular intervals upon his breast; and when his attention was called to drops of water that were actually falling at regular intervals upon the roof, he denied having heard them. He was even vexed at what Madame Sand translated by the vivid term, Imitative Harmony. He protested against the puerilities of these imitations. His genius was full of mysterious harmonies of nature, translated by sublime equivalents into his musical thought, and not by a servile repetition of external sounds. His *Prelude* was indeed full of the raindrops which resounded on the sonorous tiles of the monastery, but they were transformed in his imagination and his music into tears falling on his heart.

There is no denying the persuasive rhetoric of Madame George, but is the *D flat Prelude* the *Raindrop Prelude?* Rather is it not the *sixth Prelude in B minor?* The favorite one in *D flat* has always seemed to be the one of which Sand wrote: "Dead monks who rise and pass before the hearer, in solemn and gloomy pomp;" while the *Prelude in B minor*, though a mere sketch in comparison of the idea elaborated in the *fifteenth Prelude* above mentioned, is the foundation of the picture in which the drops of rain fall at regular intervals; the echo principle. A continual patter which reduces the mind to a state of sadness; a melody full of tears is heard through the rush of rain, adds a sentimental commentator. The artist has seized upon the most vivid moment of the story, the unexpected entrance of Madame Sand and her children, as Chopin stands in anguish rooted before his piano.

WAGNER & LISZT

WEIMAR is a little city rich in artistic memories. Here Goethe and Schiller, with a galaxy of poets, philosophers, musicians, once held sway. Later, this tiny Athens on the Ilm, as it has been called, again became an artistic center. Music was enthroned. Franz Liszt, a magnetic focus, drew to him pianists, violinists, composers, conductors; indeed, modern music, incarnated in Wagner, Berlioz and Liszt, was given its primal impulse by the extraordinary Hungarian virtuoso, innovator—he is the father of the Symphonic Poem—and charming man of the world. His efforts in behalf of the young struggling Dresden conductor, Richard Wagner, are a testimony to his unselfishness and devotion to lofty ideals. The friendship that was cemented by Liszt's aid to the political exile and revolutionist, Wagner, lasted their lives long. And if Wagner proved ungrateful it must be set down to temperamental defects, to the bitter disappointments and reverses, followed by a turn of fortunes, startling enough to upset the moral equilibrium of a less impressionable man than the great composer. But Liszt was as true as the needle to the compass. In Paris the encounter of the men had been casual. Liszt's brilliant career was then at its apogee. Wagner, unknown, making a bare living by arranging mediocre operatic tunes for the cornet, and writing letters to a journal in Germany, rather resented the superior position of Liszt. Perhaps he was envious. No matter, Liszt did nothing that could be construed as patronizing the other. When he heard *Rienzi*, Wagner's first "successful" work, he became an ardent Wagnerite; Liszt was, after Richard himself, the original Wagnerian. He did more, he produced *Tannhäuser* at the Weimar Opera House, and then the irritable composer fully realized that he had won a friend.

More followed, Wagner became involved in the Dresden up-

rising of 1849 and was "wanted by the police." He, the conductor of the Royal Opera House, had become a "traitor." In reality, his part in the affair was not significant, being more a gesture of revolt than of actual deeds. He rang the bells in a church as a signal for the insurrection, and, so it is said, bravely crossed the firing line to get a water-ice. The sybarite and socialist in the make-up of this strange character were equally balanced. Disguised as a coachman, Wagner hurriedly left Dresden and went to Weimar, where, temporarily at least, he was sure of a refuge and a hearty welcome. Liszt did not fail him, and openly expressed his delight. But the exile's stay was brief; he traveled under an assumed name and with the passport of another. Soon he was smuggled across Zürich, then proceeded to Paris. However, he did not leave Weimar before he recognized the offices, artistic and pecuniary, of the large-souled Liszt. He heard from those marvelous singing fingers music the living sounds of which were novel to him. The painter shows us the weary, almost broken-hearted, composer touched to the very core by Liszt's interpretations. And with an artistic license he has made the pianist the younger of the two. No wonder Wagner later wrote that as his eye fell on the score of *Lohengrin* "a pitiful feeling overcame me that these tones would never resound from the deathly-pale paper; two words I wrote to Liszt." And the answer swiftly came. *Lohengrin* was already in rehearsal, and August 20, 1850, witnessed its première. Franz Liszt had again demonstrated his noble love of beautiful art.

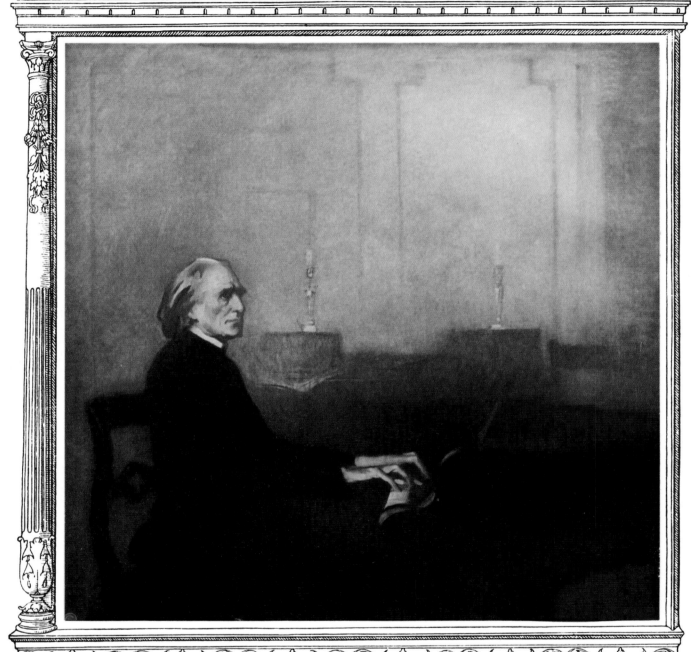

FRANZ LISZT
Painted by John C. Johansen

L I S Z T

DOUBTLESS, Franz Liszt, greatest of all pianists, composer of startling originality, a pioneer and path-breaker in modern music, above all, Liszt the magnificent and big-souled, had his lonesome, latter years, for in all the hurly-burly of his life he still found time for meditation. He shared the last two decades of his existence between Rome, Budapest and Weimar. The little Thuringian town was his preferred resting place. There he entertained both genius and royalty; there, with a patience positively angelic, he listened to those birds of passage, young pianoforte students, spread their wings before making their initial flights in the concert halls of the world. Much talent passed through his hands, much that was mediocre must have been a thorn in the side of this almost saintly artist, who practiced what he preached—that out of the hundred if ninety and nine proved failures, one grain of wheat was worth winnowing from the chaff. And such was his luck that in the vast and varied list of his pupils there occur such names, glorious in the annals of pianism, as Tausig, Von Bülow, Rubinstein — Anton certainly profited by his sojourns at Weimar—Joseffy, Pachmann, Rosenthal, Friedheim, Reisenauer, D'Albert, Sgambati, Sofia Menter—and how many others, composers as well as conductors? In Weimar Liszt walked and talked, smoked strong cigars, played, prayed—he never missed daily mass—and composed. After rambling over Weimar and burrowing in the Liszt museum one feels tempted to call Liszt the happiest of composers. A career without parallel in the history of music, a victorious general at the front of his army of ivory keys, a lodestone for men and women, a poet, diplomatist, ecclesiastic with the sunny nature of a child, loved by all who met him, and himself envious of no one— surely the fates forgot to spin their evil threads at the cradle of Liszt. Nevertheless, he was not a happy man. He had his temperamental

daemon; he was the victim of the blackest ingratitude, and from quarters least expected, from those he had most helped. Worst of all, he was not recognized during his life-time except by the "happy few" as the remarkable composer that he was; and even after his death recognition grudgingly came. Today he has fallen into his natural historical perspective, though outshone by Richard Wagner, who was in his debt for musical ideas as well as material assistance; and in the domain of the Symphonic Poem, his most significant contribution to art, Richard Strauss quite o'er-crows him. His philosophical resignation need not blind us to the hardship of his fate—perhaps the fate of many forerunners or transitional types. But Richard Strauss plays on the nerves, Liszt touches our heart.

At the old house standing in Weimar park, where Goethe and Schiller promenaded, there is a veritable museum of mementoes. What a collection of musical manuscripts, trophies, jewels, pictures, orders of nobility and letters! There may be seen besides the numerous cases containing gifts from all the crowned heads of Europe, the scores of Liszt's *Christus*, *Faust Symphony*, *Orpheus*, *Hungaria*, *Death Dance*, *Mountain Symphony*, and marble casts of Chopin and Liszt's hands. Also Liszt's favorite piano, the Steinway.

As depicted in the present canvas, he dreams of his past triumphs; of the three women who filled his life—Caroline St. Criq, Countess d'Agoult and Princess Wittgenstein; of his trials, sorrows and ultimate peace in the arms of Mother Church. The latter years are at hand, he is on the threshold of old age. The weary wonder-worker has, like Prospero, laid down his wand; the wizard Merlin is in the toils of Time. Ring down the curtain, the comedy is ended!

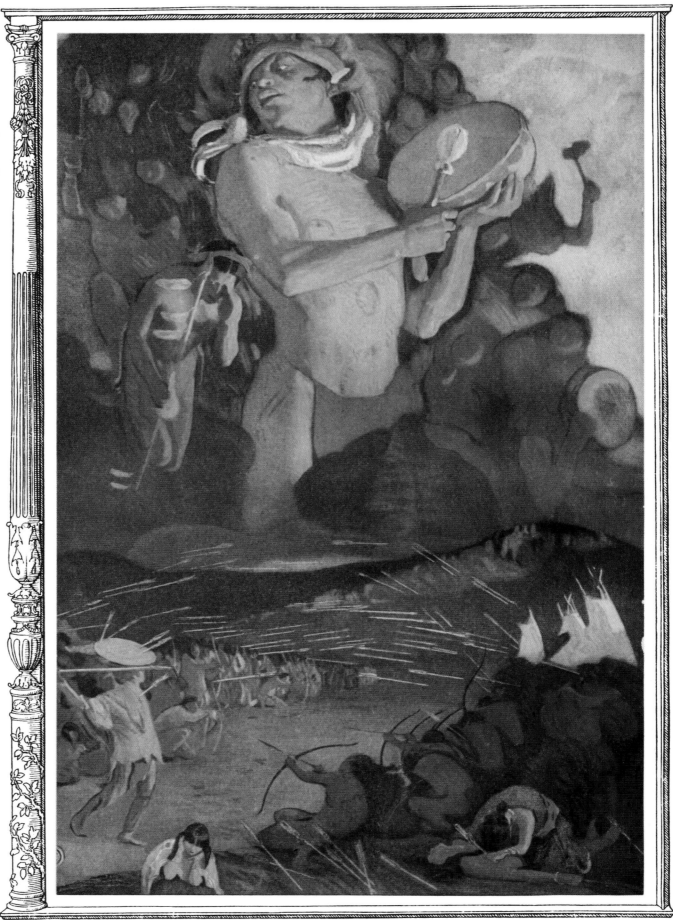

The Indian Suite
Painted by
Ernest Blumenschein

MACDOWELL

EDWARD ALEXANDER MACDOWELL was not only a noble character whose ideals were of like nobility, but he was a composer of whom America is proud. And naturally enough. A pianist of the first rank, he composed music that is romantic, is realistic, and truly native, as may be appreciated in the *E Minor Orchestral Suite*, called the *Indian*. Elsewhere I have described him as a belated romantic; he is only modern in his employment of technical devices, but the spirit of his melodies, their sweetness, grace, dreaminess, above all, their cavalier qualities, are purely romantic. He was by blood and temperament northern racial, and it is reflected in his four piano sonatas, the *Norse*, *Keltic*, *Heroic* and *Tragic* sonatas, his most significant contribution to music. But there was also another MacDowell; the poet, his soul overflowing with tenderness and caprice, who gave us the lyrics and the minor piano pieces. A fragrant fancy informs them, a poesy that is seldom encountered outside the pages of Schumann or the naïve utterances of Grieg. With the latter, MacDowell felt the cold northern night skies, punctured by few large stars; felt the shock of warring hosts about the misty, tremendous ramparts of the Scandinavian Walhalla. And, like Schumann, he could fill a song with the shy sweetness of a wild rose. In his two piano concertos with orchestral accompaniment we come upon a new man, the virtuoso MacDowell. Brilliant, dramatic, these works stem from Franz Liszt—of whose Symphonic Poems he was an admirer, an admiration, be it said, that was heartily returned by the aged Merlin of Weimar. And how MacDowell played the solo parts of these compositions!

A larger, more powerfully conceived canvas is his *Indian Suite* for orchestra, the subject of the present picture. In the score the themes are of Indian origin, deriving from the ritual and songs of various tribes.

For example, he has told us that while the first movement, the *Legend*, was suggested by the "Miantowona" of Thomas Bailey Aldrich, the themes are from an Iroquois harvest song. The *Love Song* is from the Iowa tribe, with its aboriginal syncopated rhythm. *In War Time*, the ensuing movement, is precisely the episode that intrigued the interest of the present painter. Curiously enough, its tune is less in Indian characteristics than its companion, though it is said to have been sung by the Atlantic Coast Indians; they believed it to be a melody heard in the heavens before the coming of the white race. It was thought to be a supernatural warning. The war-song and a woman's dance of the Iroquois conclude this fascinating, picturesque composition. Mac-Dowell is the pioneer in modern music of aboriginal Americans, the Indians.

The canvas of the painter is semi-fantastic. A battle furiously rages, let us imagine, between the Utes and Cheyennes. It has lasted for several days. The slaughter is dire. From the sky, so each combatant fondly believes, his war god looks down with pagan impassivity upon the conflict, the ancestor spirits of the earthly fighters. The flying arrows might be the swirl of the violins, though there is no futile attempt at literal transcription. But the spectator with a grain of imagination is bound to overhear the crash of drums and trumpets, the cries of the warriors, and the weeping of the women in the tepees. A stirring moment both in the orchestra and within the frame of the canvas.

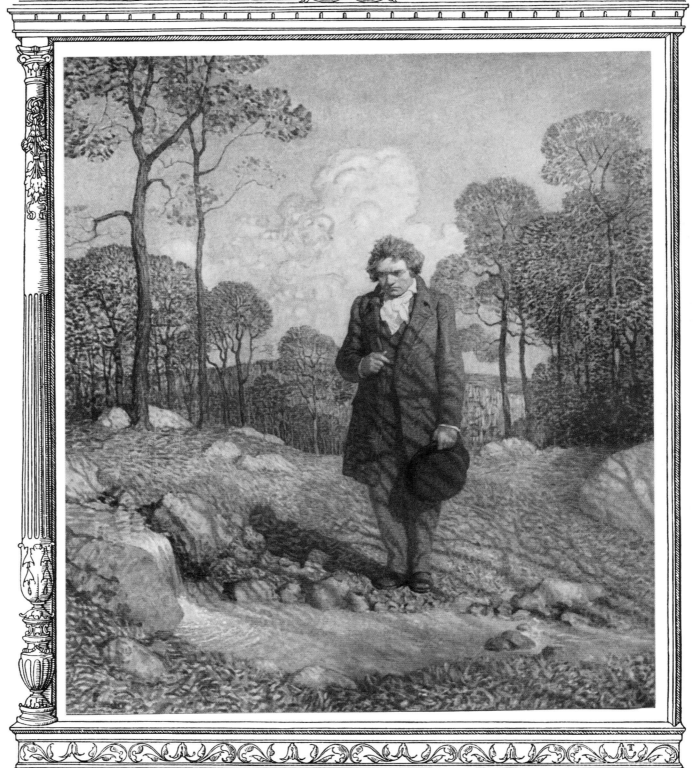

BEETHOVEN and Nature. Painted by N. C. Wyeth

BEETHOVEN

LUDWIG VAN BEETHOVEN was a profound lover of nature in all her phases. He gloried in the sunshine and did not fear the shade; once he angrily refused an umbrella, preferring to walk bareheaded in a rain storm. The first man who marched through the London streets with an open umbrella was mobbed. In Vienna the composer of the *Heroic* symphony was looked upon as suspiciously eccentric for not carrying one. Other days, other ways. He incurred, too, the disreputable title of republican because in company with Goethe he did not doff his hat to royalty. At Baden when in search of lodging he asked: "How is this? Where are your trees?" "We have none." "Then the house won't do for me. I love a tree more than a man." He said of himself: "No man on earth loves the country more. Woods, trees and rocks give the response which man requires. Every tree seems to say: 'Holy, holy.' Any one who has an idea of country life can make for himself the intentions of the author without any titles." This particularly applies to his sixth symphony, the *Pastoral*, of which he said: "Not a picture, but something in which are expressed the emotions aroused in men by the pleasures of the country, or in which some feelings of country life are set forth." It may be remarked in passing that he did not disdain the imitation in tones of natural sounds. This same *Pastoral* Symphony, with its serenity, its suggestion of open air, innocent merry-making, the singing of birds, the sudden thunder and the realistic storm, the hymn of thanksgiving and the joyous peasants footing a dance, is it not, after all, a perfect specimen of programme music?

Beethoven never missed his daily walk when living in Vienna. His body-servant, Michael Krenn, has told us of the last summer spent by the composer in his brother's house at Gneixendorf, and quoted by Grove. He spent much time in the open air, from six in the morning

till ten at night roaming about the fields with or without his hat, and his sketch book in hand; shouting and flourishing his arms, completely carried away by the inspiration of his ideas. One of his favorite proverbs was, "The morning air has gold to spare." Certainly this *Pastoral* Symphony is pervaded by vivifying ozone. His diaries, says Grove, and sketch books contain frequent allusions to nature. In one place he mentions seeing daybreak in the woods, through the still undisturbed night mists. In another we find a fragment of a hymn, "God alone is our Lord," sung to himself "on the road in the evening, up and down among the mountains," as he felt the solemn and serene influences of the hour. The most beloved of all these spots, the situation of his favorite inn, "The Three Ravens," is more than once referred to by him as the "lovely divine Brühl." Every summer he took refuge from the heat of Vienna in the wooded environs of Hetzendorf, Heiligenstadt, or Döbling, or in Mödling, or Baden, farther away. This particular spot from which he drew his inspiration for the *Pastoral* Symphony was the Wiesenthal between Heiligenstadt and Grinzing, to the west of Vienna. "Here," he said, "I wrote the Scene by the Brook, and the quails, nightingales and cuckoos around about composed along with me."

In the picture we see him bareheaded at the edge of a brook; there is the sound of running waters in the Brook scene of this Symphony; "*By the Brook*," he calls it. It is a beautiful summer day. Nature wears her gayest garb. The tone-poet drinks in the lovely scene. "The larger the brook, the deeper the tone," he wrote in his note book. And he depicted this feeling in his music, though he has warned us in this particular Symphony that it is "more expression of feeling than painting." But on Beethoven's varied palette he mixed emotion with his colors, and the world is richer by a masterpiece. Deep calling unto deep. Beethoven and Nature.

BERLIOZ

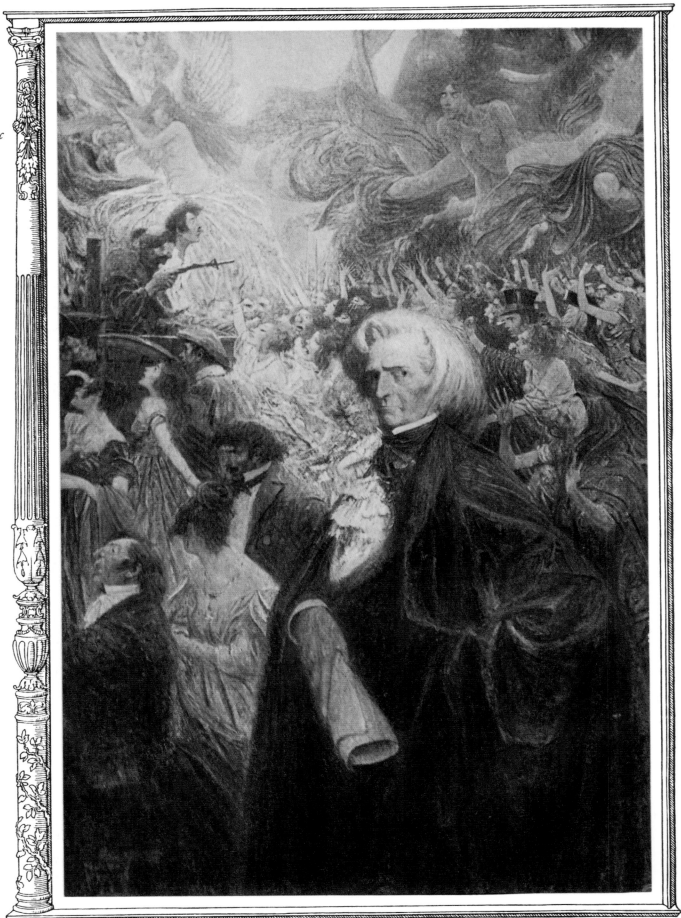

*The Fantastic
Symphony*
Painted by
Harvey Dunn

BERLIOZ

HECTOR BERLIOZ, of the flaming locks, eagle's beak, and flaming soul, thus wrote of himself and his art: "The dominant qualities of my music are passionate expression, inward ardor, rhythmical animation and the unexpected." But he forgot to add, exaggeration. He was nothing if not melodramatic. His rival, Richard Wagner, came nearer the truth when he said of Berlioz: "An immense inner wealth, an heroically vigorous imagination, forces out as from a crater a pool of passions; what we see are colossally formed smoke clouds, parted only by lightning and streaks of fire, and modeled into fugitive shapes. Everything is prodigious, daring but infinitely painful." Prodigious is the word that best expresses the genius of this great Romantic, a Victor Hugo of tone. His literary gifts were superior to Wagner's, yet Wagner it is who summed up the French composer. His frescoes are orgies. His music is like massive blocks of granite juxtaposed. It never seems to flow, but rests in monumental Egyptian rigidity. There is powerful characterization in the *Fantastic Symphony* and many extravagances. A nightmare set to music within an epical frame. In his *King Lear* overture, one of his works that best stands repetition, there are, as Hanslick puts it, the forced, the hollow, and even the trivial beside the most powerful impulses. A passionately stirred inner life leads here to violently moving exclamations, but to no connected life. You think of Berlioz in terms of the superlative. He is volcanic, oppressively agitating, frightful. He worshiped Shakespeare and Byron, but not Bach. His scores are strangely deficient in plastic polyphony. But if he is sensational, he is also picturesque. He conceived music pictorially. He was a painter, rather than a composer. He was as much obsessed by the poetic idea as the melodic. His orchestra is highly colored. He is the father of modern orchestration.

His life was a mad dream, full of sorrows and misunderstandings and poverty. He loved like a madman, cooled off hastily. He had the temperament of the ever unsatisfied, unhappy artist. His *Fantastic Symphony*, with the sub-title "*An Episode in the Life of an Artist*" (the second part of the Episode is "Lelio, or the Return to Life"), is auto-biographical, not in the precise sense, but as giving us a panoramic glimpse of his disquieted soul. In it he depicts a young artist of lively imagination who sees a beautiful woman. He loves her desperately. She realizes his ideal. He is pursued by a fixed idea of her, a musical motive that haunts all the movements of the symphony. There are dreams and passions, a ball-room, a scene in the fields, a storm, and then, convinced that his love is not returned, he poisons himself with opium. Follows a dream within a dream, a nightmare superimposed on a drugged brain. The poison does not kill; it starts whirring within the wretched chambers of his mind a picture, one worthy of morbid Edgar Poe. He has murdered the beloved one. He has been tried and condemned. He sits bound in a tumbril followed by an infuriated mob, the sky of his fancy flooded by infernal shapes. The wraith of the dear dead woman faithfully attends him as the march to the scaffold begins. The fixed idea sings in his ears. Bells toll funereally. The *Dies Irae* is chanted, his day of wrath is at hand. Then the fall of the axe on the block, and all is over, except a last nightmare; a dream of the night of the Witches Sabbath, a dream after death in which his fixed idea is burlesqued, and ending with a travesty of the hymn. You look for a final curtain, it is all so hideously dramatic. To translate this music, which is itself a translation from a picture, back to the pictorial plane is well-nigh impossible. How the artist has achieved his task in evoking a most fantastic vision may be seen in the present canvas, with its mad riot and struggling shapes. It is the March to the Scaffold re-orchestrated in color.

MOZART

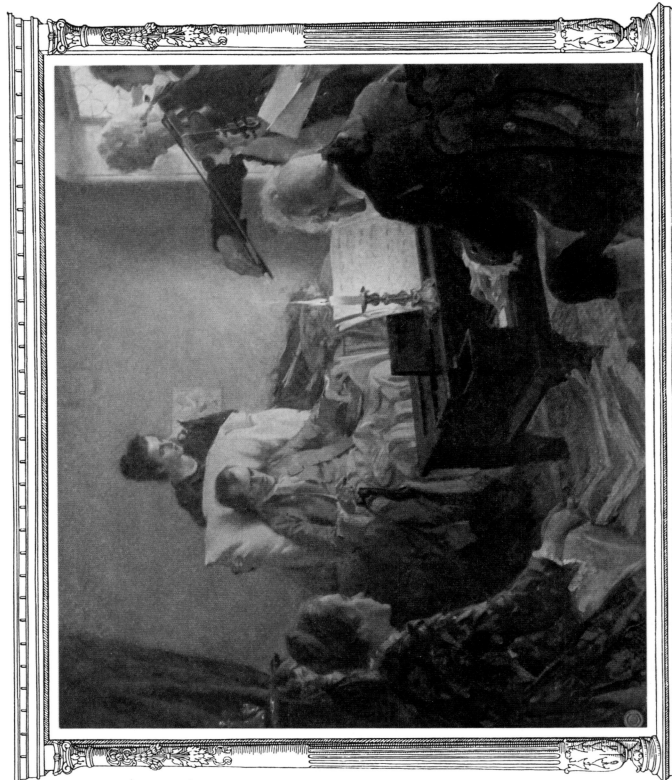

The Death of
MOZART
Painted by
Chas. E. Chambers

MOZART

LIKE all celebrated men, Mozart had his legend. For one thing, he did not in life resemble his portraits. Beethoven is another victim of the whim of the painters, who made of him a mawkish posing hero. In reality he was a peasant as to exterior, and his rough manners did not dispel the impression; but a sublime peasant. Mozart must have revealed a more attractive personality. Yet he was neither imposing nor handsome. Insignificant in figure, his mobile features atoned for his lack of presence. Nevertheless, we are usually shown a Mozart of archangelic beauty, a beauty more feminine than virile, and with little suggestion of the mercurial man whose music may be called immortal. The Russian novelist Turgenev said that there were at least a thousand princesses in whose arms Chopin was supposed to have died, and there must be a thousand painters who selected as a subject the death-bed of Wolfgang Amadeus Mozart.

It is a theme always provocative of interest, this dramatic ending of a marvelous musician at an early age. How often have we not looked at that operatic ensemble—the moribund composer surrounded by his sorrowing family and friends. A huge chorus supplemented by an orchestra deliver the solemn and tragic measures of the *Requiem*, upon the pages of whose manuscript the ink is hardly dry. Such a volume of sound would have waked the dead, or speedily sent to his grave the dying man. It is very effective artistically, but it is not entirely veracious. Mozart did compose his *Requiem* during the last days of his too brief existence. The composition of the work was interrupted by spells of fainting. He was in such a morbid condition, superinduced by worry, overwork, excitement, not to mention dissipation, that he experienced hallucinations. He believed that he had been poisoned, whereas the cause of his death was malignant typhus. But he finished the *Requiem*.

Whether he heard it sung in its entirety is still disputed by musical historians. Perhaps he did. It does not much matter if he did or not, so far as legends and pictures are concerned. The saddest part of his life was not his death, but his funeral. Hastily taken to the cemetery by a few faithful ones, his actual resting place is not positively known, a fitting commentary on the irony of human destiny.

But though the mortal part of Mozart has vanished, his music lives for our delectation. No more charming tones were ever penned by man; charming and erudite, dramatically powerful, yet bewitching. His *Don Giovanni* has not paled before the more exotic scores of Richard Wagner. It held its own in company with the *Magic Flute* during the accustomed temporary oblivion that so often follows the death of a great artist. The vivacious operettas and one-act lyric compositions are very popular in Europe. The *G minor* and *C major* —the *Jupiter Symphony* figure on the programs of every important or provincial orchestra on the globe. The piano *Concertos* in *D major* and *D minor* are prized by musical pianists, while the *Sonatas* are the companion volume to Beethoven's—whose forerunner Mozart was in the *C minor Fantasia* and *Sonata*. The serenity, grace, blitheness of this music with its native wood-note wild is without parallel. Mozart, the sunny-souled, has his legend, and a lovely one it is. The picture of the artist is more intimate than the conventional canvas. It speaks for itself. Mozart hears his inspired music, the music of the spheres, for Death, the arch consoler, is playing the final movement in the composer's gracious symphony of Life.

VERDI

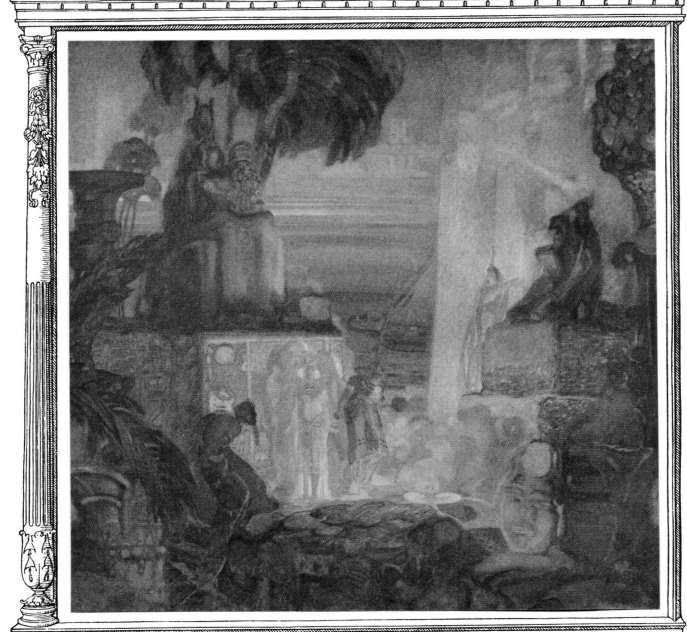

VERDI—Aida
Painted by Henry McCarter

VERDI

AIDA is instanced as an example of the parting of the musical ways in Verdi's style. Perennially popular operas as Wagner's *Rienzi* and Meyerbeer's *Huguenots*, both tuneful pageants, are outdone by *Aida* with its massive decorations, imposing music and romantic story. As a matter of fact, it is replete with more Meyerbeerisms than any opera since *L'Africaine*. The resemblance to Meyerbeer does not stop at the libretto; there is the same flamboyancy and predilection for full-blown harmonies and lush melodies, exotic color. Wagner, too, influenced the music. But it is the Verdi opera now most beloved by the public and enjoys a vogue similar to that of *Il Trovatore* in years gone by.

Contrary to general belief, *Aida* was not written to celebrate the completion of the Suez Canal, nor to open the Italian Opera House at Cairo; the work happened to be a commission from the Khedive in the early winter of 1871 with a libretto on Egyptian subjects; hence the accepted and erroneous version of its birth. The artist has selected the third act, the Nile scene with its tropical gorgeousness, its magic and moonlight, its impassioned lovers and their betrayal into the hands of the enemy through jealousy and treachery. Musically, it is the climacteric of lyric rapture and abandonment and thrilling drama in *Aida*.

The superficiality of Verdi's earlier operas should not blind us to the promise and potency of their music. It is the music of a passionate Italian temperament, music hastily conceived, still more hastily jotted down, and tumbled anyhow on the stage. Musical Italy was altogether devoted to the voice. As for the dramatic unities, the orchestral commentary, the welding of action, story and music, they were negligible. Melody, irrelevant, fatuous, trivial melody, and again melody, was the desideratum. The wonder is that an orchestra was used, except that it made more noise than a pianist; that costumes were worn,

except that they looked braver, gayer in the flare of the footlights than street attire. The singer and the song was the entire excuse for opera, the rest was sheer waste. Consider the early Verdi opera. A string of passionate tunes bracketed in the well-worn cavatina-cabaletta manner; little attempt at following the book—and such awful libretti!—for the orchestra, a strumming machine, without color, appositeness, rhyme or reason, the music febrile and of a simian-like restlessness. It was written for persons of little musical intelligence, who must hum a tune, or ever after criticise it with contempt. Verdi could compose such tunes by the hundreds, vital dramatic tunes. Think of the saddening waste of material in *Oberto, Nabuco, Lombardi, Ernani, Macbeth, Foscari, Attila, Luisa Miller* and *Masnadieri! Rigoletto, La Traviata, Il Trovatore* perhaps hold the boards today because of their intrinsic musical worth and dramatic effectiveness, but the mists of oblivion are stealing over them. A star cast or Caruso alone saves them.

Yet they prefigure the later Verdi. *Otello* is true music-drama. The character drawing is that of a master of his art. The plot moves in majestic splendor, the musical psychology is often subtle. At last Verdi has flowered. His early music, smelling ranker of the soil, though showing more thematic invention, was but the effort of a hot-headed man of the footlights, a seeker after applause and money. But before he wrote the score of *Otello* his *Aida* had been born.

Today the play's the thing to catch the conscience of a composer. In Verdi's *Falstaff*, the most noteworthy achievement in the art operatic since *Die Meistersinger*, we are given true lyric comedy. In form it is novel. It is not opera buffa, nor yet is it opera comique in the French sense; indeed, it shows a marked deviation from its prototypes; even the elaborate system of Wagnerian leading motives is not employed. It is a new Verdi we hear. Not the Verdi of *Il Trovatore, La Traviata,* or *Aida*, nevertheless a Verdi brimful of the joy of life, naïve, yet sophisticated. A marvelous compound is this musical comedy, in which the music follows the text, and no concessions are made to the singers or to the time-honored conventions of the operatic stage. The composer has thrown overboard old forms and planted his victorious banner in the country discovered by Mozart and conquered by Wagner.

A Midsummer
Night's Dream
Painted by
Carl Anderson

MENDELSSOHN

WITH the solitary exception of Chopin, the popularity of Mendelssohn's piano music has never been rivaled. The *Songs without Words* were once idolized by young misses, and with sufficient cause. They are agreeably melodic, the titles are characteristic, they are eminently playable, well written, and suffused with sentiment. The short-story in music, gilt-edged lyricism, as they have been nicknamed, they seldom disturb the placid drift of one's mood after an enjoyable dinner. First aids to digestion in the more orderly and spacious times of our grandparents, they are a little foreign to the mood of the present haste-loving generation. So behold them, with the oft-played piano concertos, handed over to the tender mercies of the pedagogue and "young lady pupils." Some of these compositions deserve a better fate. At least four of the *Songs without Words* appear at wide intervals on the programs of public piano recitals. Paderewski occasionally plays a few with much sentiment, and De Pachmann always won tumultuous applause for his finished performance of the *Spinning Song*, and the *Rondo Capriccioso*—that shibboleth of the conservatory. Nevertheless, it is a pity that the other compositions for the piano have become almost obsolete. The swiftness, delicacy, elfin lightness and brightness of the character pieces should preserve them in the affections of amateurs. They set off the polished talent of Mendelssohn to advantage; they are true caprices; and are, as Bernard Shaw so happily says, "light without heat." Mendelssohn never tears passion to tatters. He is too well-bred to indulge in passion. He embodies the gentlemanly interest in music.

But the Felix Mendelssohn-Bartholdy of *A Midsummer Night's Dream!* That is a tale of another color, a tale in which may be found charm, fantasy and the "horns of elf-land faintly blowing." Shakespeare's exquisite romanticism is here allied to an almost mirac-

ulous formal sense in composition. And from the pen of a seventeen-year-old lad! It would be hardly conceivable were it not the truth. "Today or tomorrow," wrote Mendelssohn on July 7, 1826, "I shall begin to dream the *Midsummer Night's Dream*"; and a month later that dream was clothed in tone. The poetry of Shakespeare was given its ideal musical interpretation. As Frederick Niecks has written, "What constitutes the chief originality of the overture is the creation of the fairy world with its nimble, delicate and beautiful population." Before our mind's eye are called up Oberon and Titania as they meet in "grove or green by fountain clear or spangled starlight sheen"; the elves who, when their king and queen quarrel, creep into acorn cups, their coats made of the leathern wings of rere-mice; peaseblossom, cobweb, moth, and mustard seed; and the roguish sprite Puck, alias Robin Goodfellow, who delights in playing merry pranks. In this especial genre, Mendelssohn surpassed himself, though he wrote music of profounder import in the *Hebrides Overture*, and *Elijah*.

When recalling the tripping measures of this airy fairy comedy we should not forget the humans—Duke Theseus and his betrothed, Queen Hippolyta, Lysander and Hermia, Demetrius and Helena the lovers; and the comic Athenian citizens—Quince, Snug, Bottom, Flute, Snout and Starveling; nor the immortal head of the Ass. The incidental music written seventeen years afterward is in the inevitable key of the play; the *Scherzo*, *Notturno* and *Wedding March*.

The artist has obviously stressed the decorative element of this fairy episode. The portrait of the composer musing over his youthful masterpiece is symbolical, for the features of the boy Mendelssohn are not as familiar as those of the dignified composer. He is the Prince Fortunatus among musicians. The son of a wealthy man, the grandson of a philosopher, his career was like a midsummer night's dream. Happy he was from cradle to grave. Aptly was he named **Felix**.

HANDEL

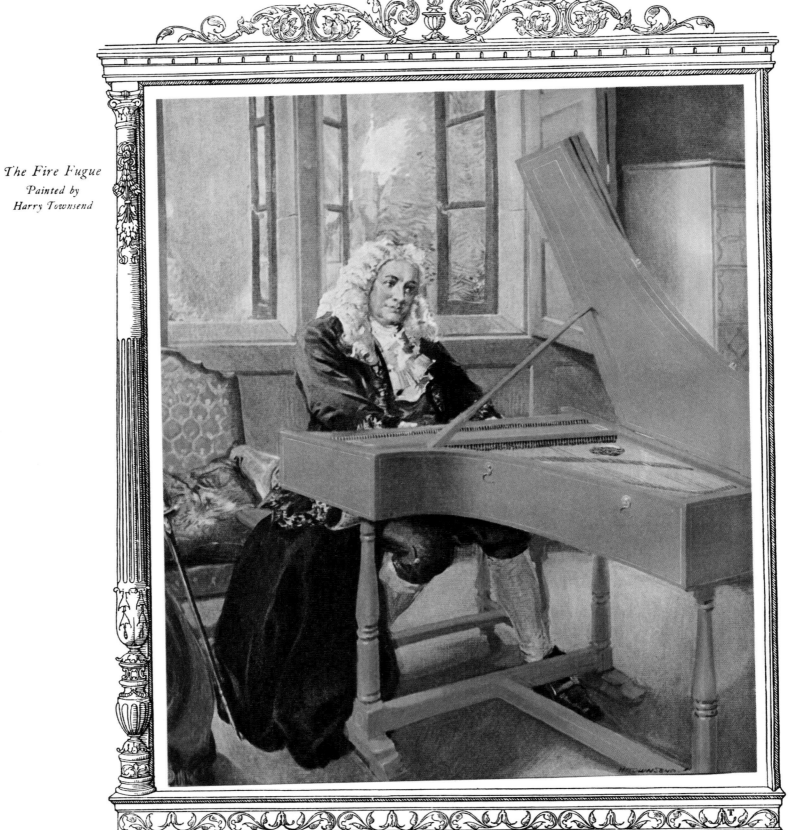

The Fire Fugue
Painted by
Harry Townsend

HANDEL

THE most imposing figure in the history of music was George Frederic Handel; imposing in his music, his person physically imposing. He has been called, and not without reason, the greatest of English composers, though German born. He still dominates English music from Purcell to Elgar, notwithstanding the advent of two such dangerous rivals near this throne as Mendelssohn and Wagner. But the popularity of the *Messiah* has never been threatened. It is perennial. Its composer, sturdy, dogmatic, brooking no opposition, as choleric as Dr. Samuel Johnson, to whom in certain characteristics, he bears a surprising resemblance, was a glorified John Bull. The music he so fluently penned—and so blithely appropriated from other men's compositions—is not always profound, though harmonious, pleasantly sonorous, cheerful and healthy. This particularly refers to the concertos, suites, fugues and overtures. Occasionally melancholy is sounded, a sweet pathos that reflects the spirit of his epoch, which was more decorative than poetic. But he could sound the epical note, blow it big, sonorously and soul-stirringly through his mighty trumpet, and how big, how exalted it all is we need but listen to the *Messiah*.

Yet there was an introspective Handel, a Handel who is said to have wept bitter tears while composing "He was despised and rejected of men," in the *Messiah*. There the solitary suffering of the great tone painter of primal music is expressed in exquisite accents. He, the proudest man of his day, the favorite of two sovereigns, the honored artist, had been despised and rejected in his love suit. The haughty, domineering musician who seems so superb in his court costume, powdered wig, sword at side, had his moments of depression and brackish grief, despite his pugnacity, and brutality to his singers. (He is said to have suspended an unfortunate lady, who had stubbornly

refused to sing, out of the window till she surrendered. It sounds too good to be true.) Sitting one morning at his harpsichord in his pleasant music-room and near the open window whence penetrated the street cries and noises of London, Handel preluded. His power of improvisation was almost as extraordinary as Johann Sebastian Bach's. He idly taps the keys of the archaic harpsichord. Soft spring airs steal in the apartment. Suddenly a fire engine passes, sounding its tinkling signal of warning. The three iterated notes of B piqued the fancy of the composer. He struck them out on the keyboard, three B's, and at once followed the echoing answer from above. His imagination fired, Handel put forth all the resources of his art; two, three and four voices pursued each other in the labyrinthine cross-game of the fugue. Like the palimpsest of some antique manuscript there peeped through in tones of fire other meanings, other proclamations. The complex contrapuntal knot was tied at its tightest. Then came the resolution of the theme in booming octaves. It is like the concentrated roll of a wave on a sullen, savage shore. We are listening to the *E minor fugue*, the *Fire Fugue*, so christened by some one who had a barren fancy, for this is no mere imitative musical etching depicting the flight of a fire engine, but the creation of emotional art.

It vibrates with feeling, and the thrice repeated B is but the masterful assertion of passionate love and anger hot from the heart of this man whose pride was like Lucifer's. There is melodic sublimity and the atmosphere of the vast ocean, which pulses in magnificent rhythms. One forgets the science—Bach's fugues are more logical and severe—for the mystery: Handel spilled his great soul in the *Fire Fugue*.

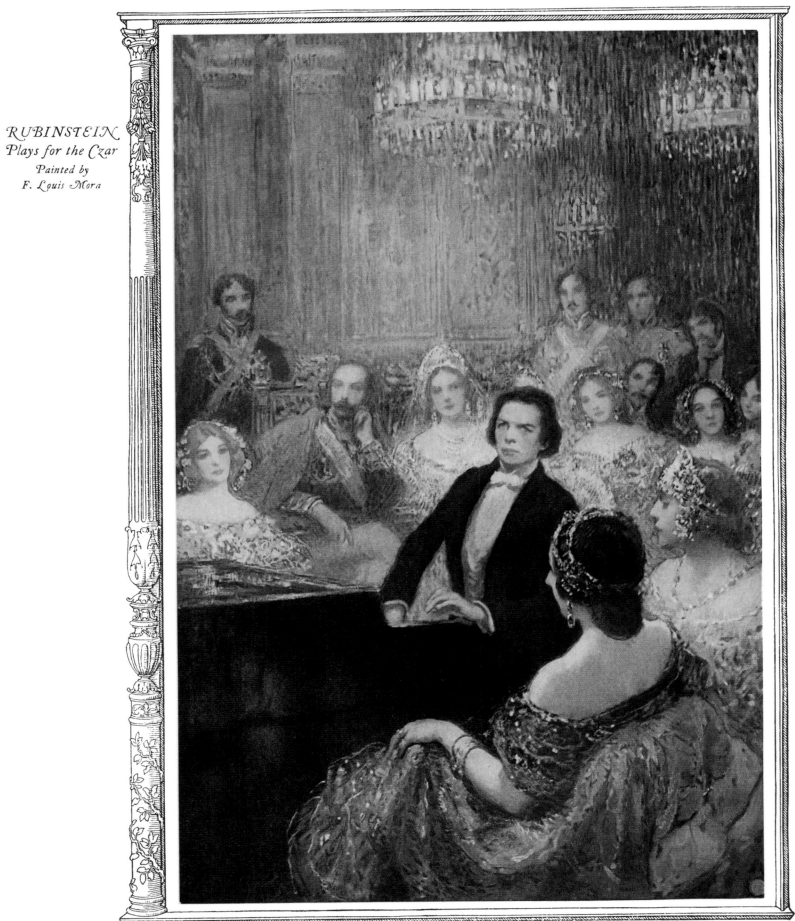

RUBINSTEIN
Plays for the Czar
Painted by
F. Louis Mora

RUBINSTEIN

ANTON RUBINSTEIN plays for the great White Czar and Czarina of all the Russias! It is like reading from the page of some forgotten romance, yet it is not so many years ago that a Czar and Czarina sat upon the throne of the Russian empire and occasionally lent a gracious ear to the piano playing of Rubinstein. The old order has changed and czars have gone out of fashion. Sadder still to the lover of music is the fact that with the death of Rubinstein no artist of his emotional caliber has appeared upon the scene, nor is there likely to be one. That prodigious trinity, Liszt, Rubinstein, and Tausig, represent the romantic school of playing. They had all the virtues and few of the vices of the hierarchy. Rubinstein, an impressionist at the keyboard, an impressionist whether he improvised or composed—in his case usually the same thing—was the most emotional pianist of them all. Other men have revealed more intellectuality in their interpretations—consider Von Bülow; have displayed more versatility—there is Liszt; have possessed a more polished technique—Karl Tausig. But Rubinstein outpaced the others in his overwhelming passion. He was volcanic. He was as torrid as midday in the tropics. His touch melted the heart in a Chopin nocturne, and he could thunder like a storm cloud, thunder and lighten. He knew all schools, all styles and all their nuances. The plangency of his tone, fingers of velvet, fingers of bronze, the sweep, audacity and tenderness of his many styles—ah! there was but one Anton Rubinstein.

Behold him then as pictured by the fancy of the artist, sitting in the center of Petrograd's court circle. He seems inspired. What is he playing? Possibly one of those tiny portraits he named "*Kamenoi-Ostrow*," the Isle of Kamenoi, which stands, a pleasant green oasis in the river Neva, at Petrograd. It is a recreation park and boasts a palace.

The music, like so many pieces of Rubinstein, became popular, too popular, as did his famous *Melody*. Improvised, like the majority of his piano compositions, it is not destined to immortality. The same may be said of the larger works, the symphonies, operas, even the chamber-music. The reason is not far to seek. Haste in composition is not alone the cause of the decay and dissolution of his music. It is the lack of personal profile. He wrote, not like Moussorgsky, genuine Russian music, but music that smacks too often of the lamp academic. He detested Wagner, nevertheless Wagner lives and the music of Rubinstein is already short of breath. More's the pity, for he is essentially a melodist. He shook melodies out of his sleeve. His songs are charming. He fairly fascinates us with his piano music, yet the present generation votes him old-fashioned and hardly worth the trouble of study. So, this is the tragedy of a man whose life, like Liszt's, was a blazing torchlight procession through the broad avenues of the world, and now become a candle that wavers before each critical wind down the Corridor of Time. But living he was a symbol of power, and when he smote the keys his music was magical. Thrice eloquent he plays for the beautiful women who surround him. His leonine mane is less disheveled in the more decorative atmosphere of the palace. He is barbaric when he wills, and those Calmuck features can become passionate, but here he coos as softly as a sucking dove. And the exquisite creatures sigh, the Czar is pensive, the Czarina conceals her disquieted soul behind the conventional court mask. It is a glittering episode in the northern Babylon, in the life of a noble artist, in the life of a Czar. But the handwriting is there on the wall for those who can read, and in letters of fire—*Mene! Tekel! Upharsin!*

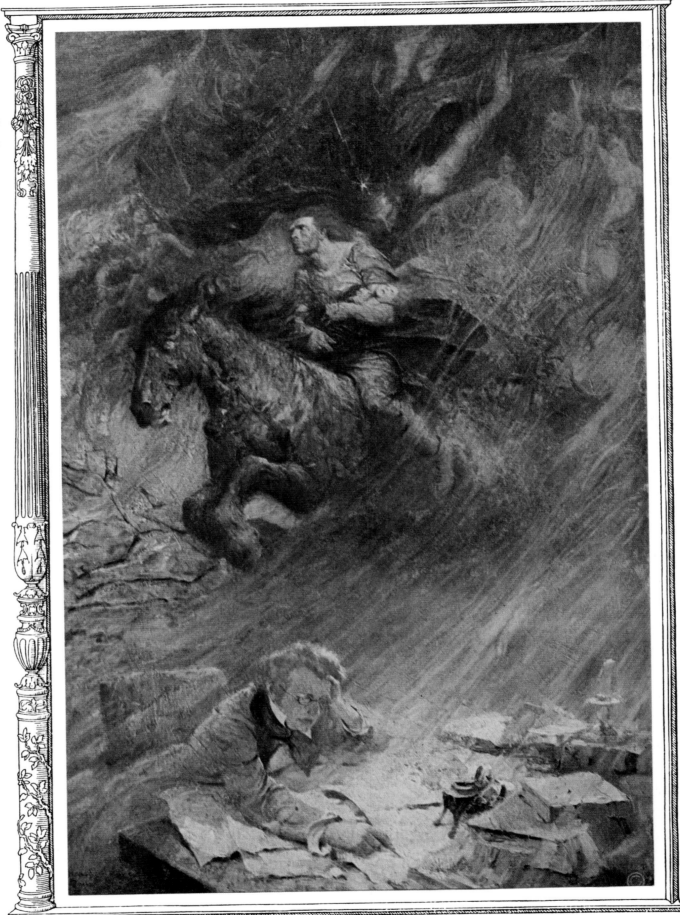

SCHUBERT
*Composing the
Earl-King*
*Painted by
Harvey Dunn*

SCHUBERT

WHAT is this apparition in the darkened skies that flies before the storm-blasts? A father rides in the night on a fleet horse, across his arm his sick child. Behind them is the grisly King of Terror, Death. The howling winds deaden the whispered words of the Erlking, but the child hears and his pitiful little body shudders; he is fainting with the fear of impending calamity. The thud of the horse's hoofs, though he treads air, does not dull the hearing of the doomed one. Thou lovely child, come with me to my magic abode, where flowers and glittering costumes await thee! There my daughter shall weave for your enraptured eyes the silken paces of the dance, weave garlands, singing haunting songs all the while! But the child is terrified. The voice that filters through the porches of his ears has a sinister sound. He sadly mistrusts these promises of bliss. He longs to stay with his father, who presses him so closely to his bosom. He clings all the more as through the shriek of the infernal gale which blows from the mouth of the tomb the voice redoubles its seductiveness. Come, lovely child, come play with me in the enchanted land of dreams! My father, my father, cries the child, don't you hear, don't you see the Erlking with his crown, who begs me to leave you? My child, answers the father, it is the mist and wind that fill your eyes and ears! Have no fear! I hold you fast! But father, my father, he threatens now! Ah! father, he has sadly wounded me! For answer the father rides the swifter. When he reaches his home a dead child he carries in his arms. Death has outstripped him in the eternal race for a human soul.

Goethe's immortal ballad has been often set to music, but to Franz Schubert must be awarded the prize. He is as much identified with the Erlking as the poet himself; and Goethe did not even acknowledge the composition when sent to him. It was composed by

Schubert at the age of fifteen and is set down as his opus 1. Such precocity has seldom been rivaled.

In the picture it is the mature Schubert who faces his desk, music paper before him, poring over his notes, for the artist justly enough has given us the portrait by which he is best known. The fierce rush of the horse, whose hoofs reverberate like the octaves of the thrilling accompaniment, evoke the tragic atmosphere, and the fantastic nocturnal spectres. Surely Schubert was the first Romantic in tone, as well as the greatest composer of songs. His melodies sing in the heart long after they have ceased humming in the ears. Poor, timid, homely —that is, if a genius can ever be ugly—Schubert! Despised and rejected, his love scorned, his music at first unplayed, unsung, he is yet the one composer who shall remain eternally young. Schubert is romance. Even when he is prosy his music prose is tipped with lyric gold. On his sick bed Beethoven acknowledged that he was the divine spark; he could have said, tongues of fire. Like Beethoven, he loved the fields and woods, lakes and rivers, clouds and moonlight, and like Beethoven he saw the stars. Schumann told the truth of Franz Schubert when he wrote: "His profound musical soul wrote notes where others employ words." He is the poet of youthful, loving hearts.